THE
GETTYSBURG ADDRESS

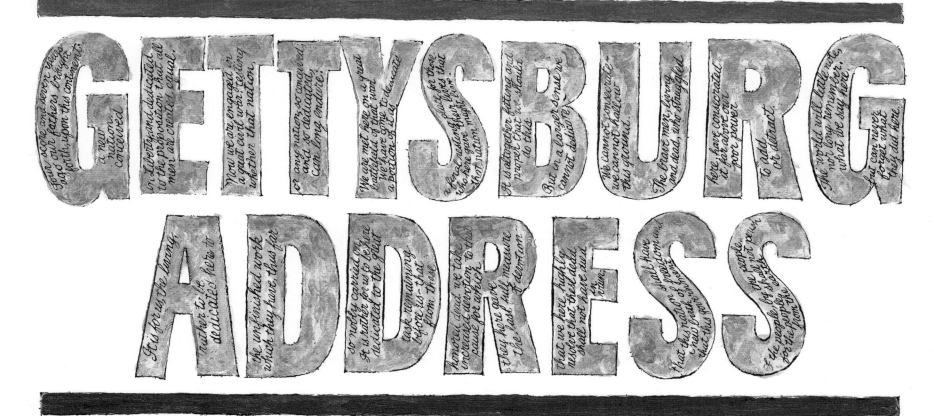

And the Thirteenth Amendment to
The Constitution of the United States of America

Inscribed and Illustrated by Sam Fink
With an introduction by Gabor Boritt

welcome
BOOKS

new york • san francisco

In memory of my father, Morris,

who set me on the path;

my beloved son, Mace,

who packed a lifetime into his twenty years;

my scholarly son, David, and his wife, Mirjam,

whose spirits keep me going;

my dear friend, Dick Bahm,

who encouraged me in this work;

and my publisher, Lena Tabori,

who gave it one more hurrah!

—sf

Introduction

When the world hears the Gettysburg Address, it hears America saying, *This is who we are at our best*. The world has listened to Lincoln's words for all these many years because their message is so universal. In 1863, the American president had specific political purposes in mind for a specific time and place, but, surely, he also hoped that his words and deeds might live beyond his own day. So it turned out to be. If his speech at Gettysburg grew into secular gospel for Americans, it also came to be deeply admired around the globe.

The great Russian novelist Leo Tolstoy called Lincoln a saint and recited words about him from a Muslim chief in the Caucasus: "He spoke with the voice of thunder; he laughed like the sunrise and his deeds were as strong as the rock and as sweet as the fragrance of the rose."

About that same time, Mahatma Gandhi spoke in a like spirit: "Though America was his motherland and he was an American, he regarded the whole world as his native land." Later in independent India, Jawaharlal Nehru kept a brass mold of Lincoln's right hand nearby. "I look at it every day, and it gives me strength."

Sun Yat-sen, the founder of modern China, would explain the goal of his life as creating a government of the people, by the people, for the people.

As Africa shook off colonial powers, the new independent countries, one after another, issued postage stamps with Lincoln pictured upon them. And Nelson Mandela, South Africa's first post-apartheid prime minister, looked at Lincoln as a model and often emulated him.

In Latin America, during a Caracas performance of Aaron Copland's "Lincoln Portrait" in the 1950s, when the final words came—*"por el pueblo y para el pueblo"* (a government of the people, by the people)—the audience erupted. An American foreign service officer later explained that this was the beginning of the end of the dictatorship.

Student demonstrators around the world—in Hungary in 1956, Teheran in 1979, Tiananmen Square in 1989—called upon the very same words. In the twenty-first century, when Pope John Paul XII arrived in the United States, he knelt to kiss the soil—and when he left he quoted Lincoln. Of course, around the globe, and in the United States, the Gettysburg Address has been misused to support unsavory causes. But the American *saint's* words have more often elevated people and moved them to positive action.

They still do.

—Gabor Boritt

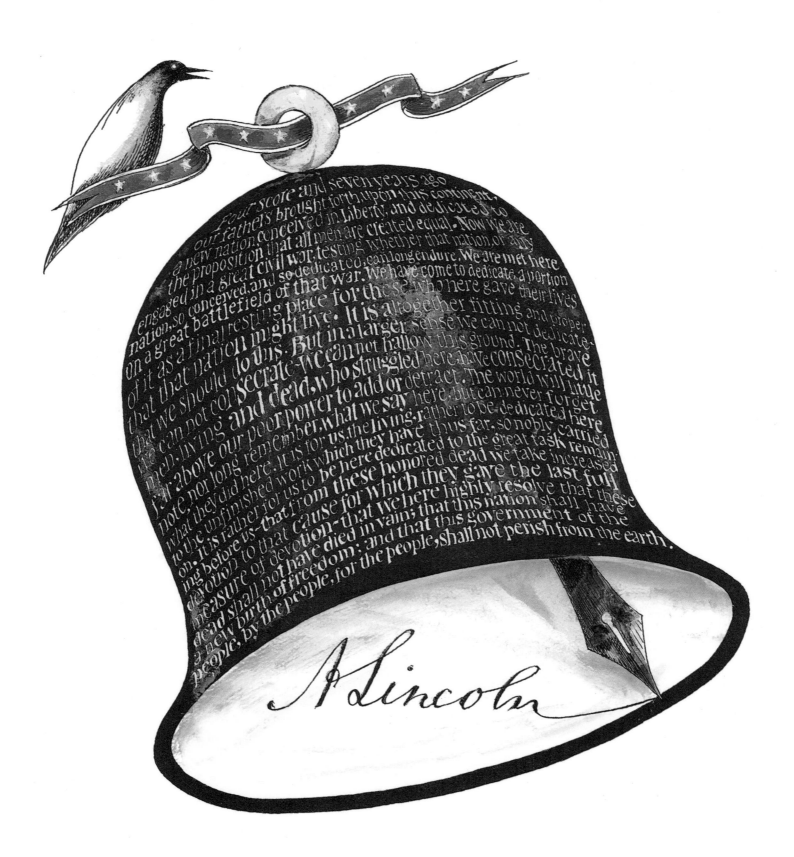

Four score and seven years ago our fathers brought forth upon this continent, a new nation conceived in Liberty, and dedicated to the proposition that all men are created equal. Now we are engaged in a great civil war, testing whether that nation or any nation so conceived, and so dedicated, can long endure. We are met here on a great battlefield of that war. We have come to dedicate a portion of it as a final resting place for those who here gave their lives that that nation might live. It is altogether fitting and proper that we should do this. But in a larger sense we can not dedicate—we can not consecrate—we can not hallow this ground. The brave men, living and dead, who struggled here have consecrated it far above our poor power to add or detract. The world will little note, nor long remember what we say here, but can never forget what they did here. It is for us the living, rather to be dedicated here to the unfinished work which they have thus far so nobly carried on. It is rather for us to be here dedicated to the great task remaining before us—that from these honored dead we take increased devotion to that cause for which they gave the last full measure of devotion—that we here highly resolve that these dead shall not have died in vain; that this nation shall have a new birth of freedom; and that this government of the people, by the people, for the people, shall not perish from the earth.

A Lincoln

Here, illustrated and inscribed, the words spoken by President Abraham Lincoln at Gettysburg, Pennsylvania, on November 19, 1863. They ring as true today as they did then. Now they tell us where we've been, who we are and what we should strive to be.

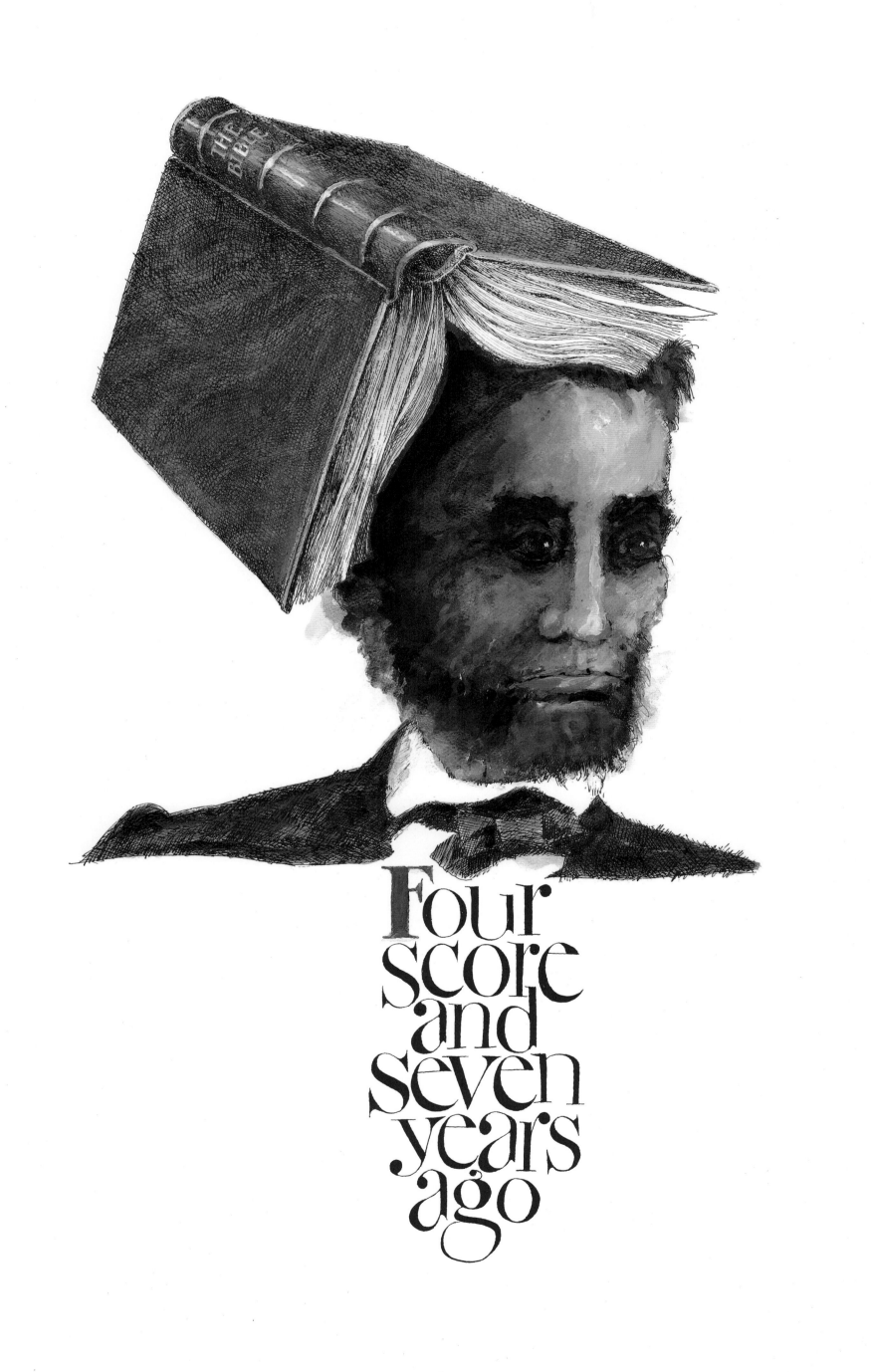

Four
score
and
seven
years
ago

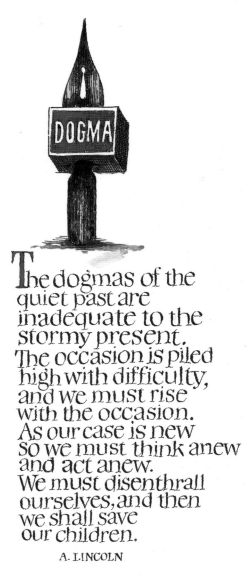

The dogmas of the
quiet past are
inadequate to the
stormy present.
The occasion is piled
high with difficulty,
and we must rise
with the occasion.
As our case is new
so we must think anew
and act anew.
We must disenthrall
ourselves, and then
we shall save
our children.

A. LINCOLN

our fathers brought forth,

The "fathers" who brought us forth, the 56 signers of The Declaration of Independence:
Josiah Bartlett, William Whipple, Matthew Thornton ★ John Hancock, Sam Adams,
Robert Treat Paine, Elbridge Gerry, John Adams ★ Stephen Hopkins, William Ellery
★ Roger Sherman, Oliver Wolcott, William Williams, Samuel Huntington ★ Lewis Morris,
Philip Livingston, Francis Lewis, William Floyd ★ John Witherspoon, Richard Stockton,
Francis Hopkinson, John Hart, Abraham Clark ★ Benjamin Franklin, John Morton, James Wilson,
Robert Morris, George Taylor, George Ross, James Smith, George Clymer, Benjamin Rush
★ Caesar Rodney, George Meade, Thomas McKean ★ Charles Carroll of Carrollton, William Paca,
Samuel Chase, Thomas Stone ★ Richard Henry Lee, Thomas Jefferson, Benjamin Harrison,
George Wythe, Francis Lightfoot Lee, Carter Braxton, Thomas Nelson JR ★ Joseph Hewes,
John Penn, William Hooper ★ Arthur Middleton, Thomas Lynch JR, Edward Rutledge JR,
Thomas Heyward JR ★ Lyman Hall, Button Gwinnett, George Walton.

Towering genius
disdains
a beaten path;
it seeks
regions
hitherto
unexplored.

ANONYMOUS

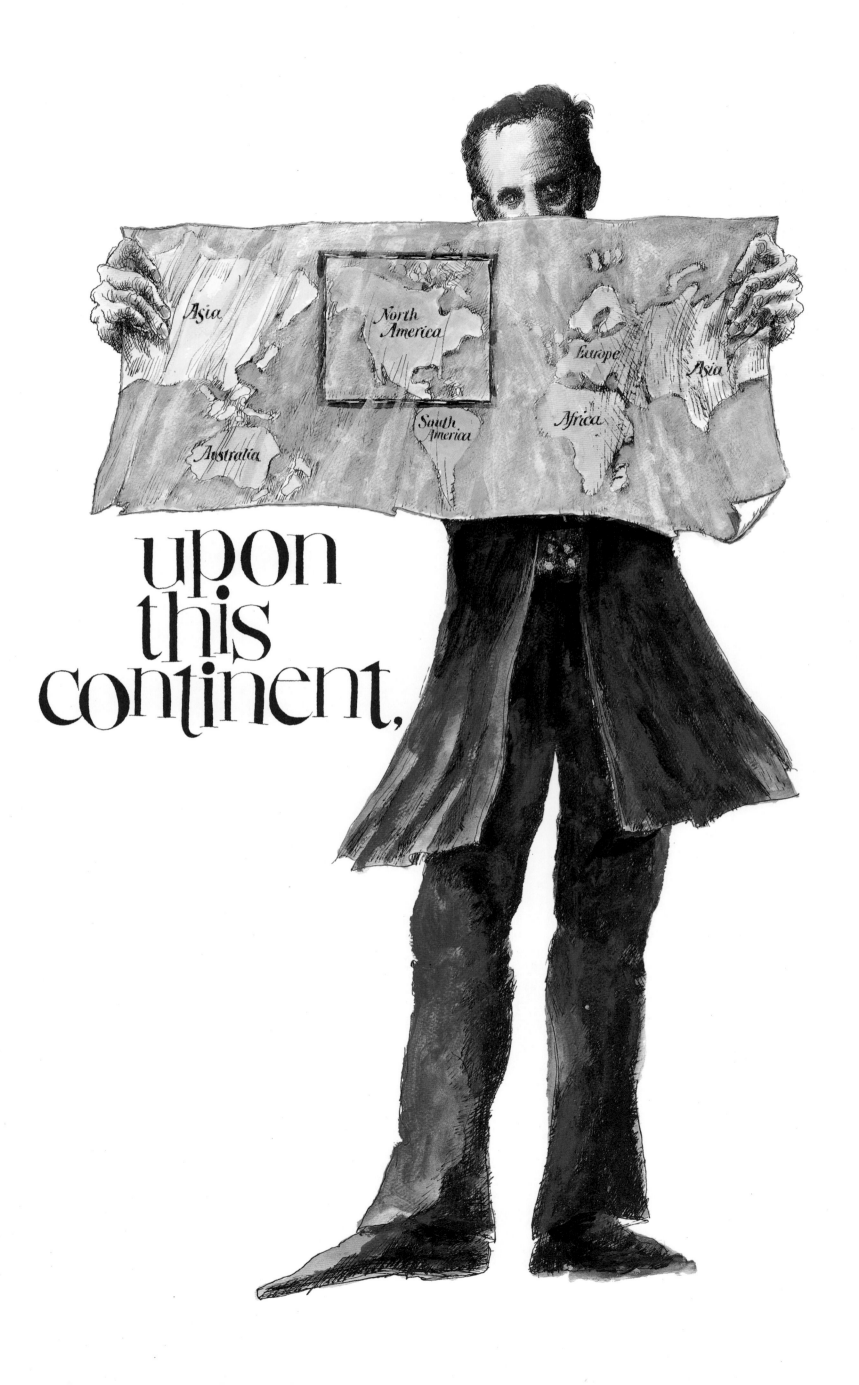

upon this continent,

His grave a nation's
heart shall be,
His monument
a people free!

CAROLINE A. MASON

New Hampshire
Massachusetts
Rhode Island
Connecticut
New York
New Jersey
Pennsylvania
Maryland
Delaware
Virginia
North Carolina
South Carolina
Georgia

a new nation,

...let every man remember
that to violate the law
is to trample the blood
of his father, and
to tear the charter
of his own and
his children's liberty.

A. LINCOLN

Conceived in Liberty,

Important
principles
may
and
must
be inflexible.

A. LINCOLN

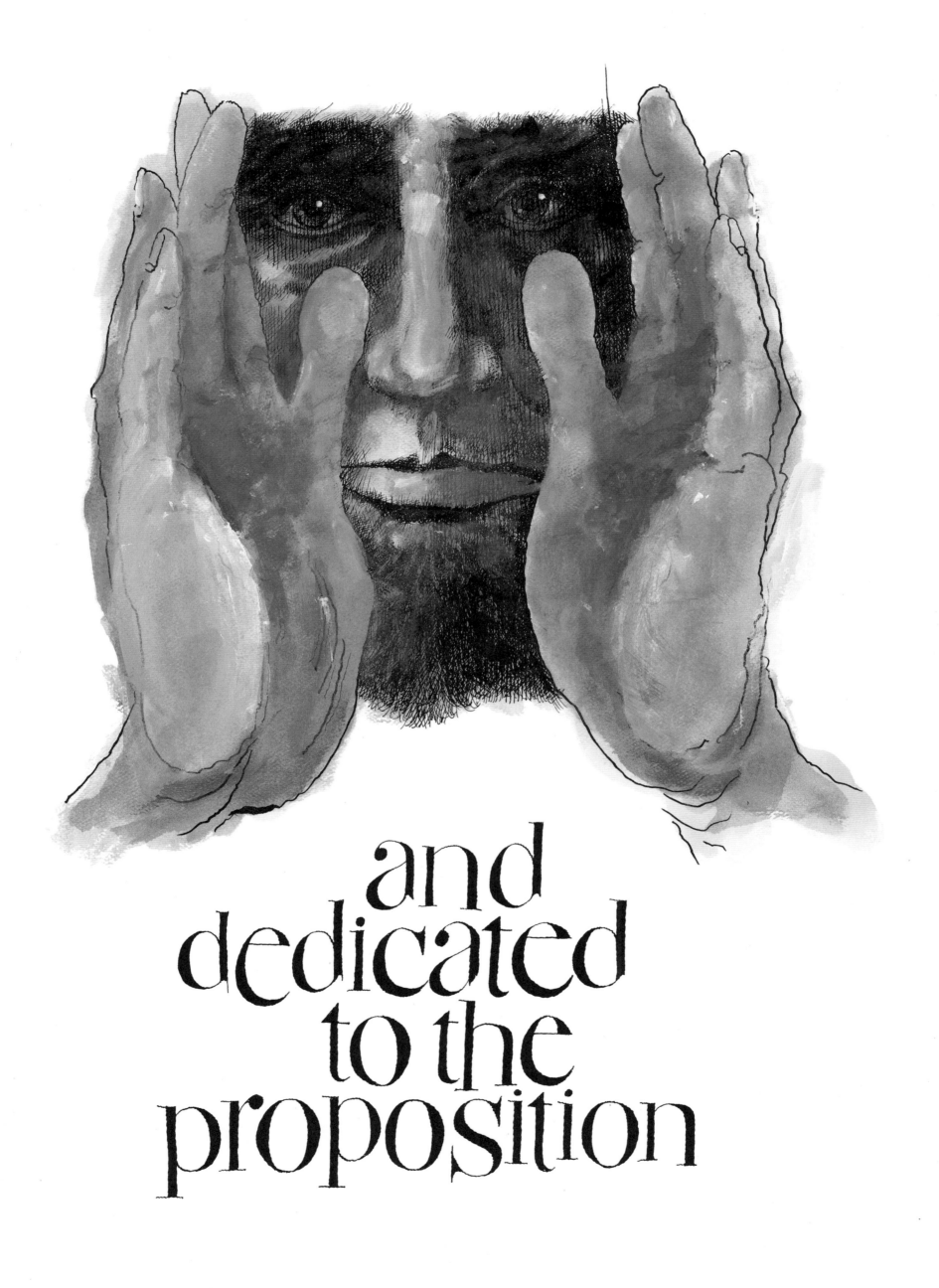

and
dedicated
to the
proposition

No man
is good enough
to govern
another man
without
that other's
consent.

A. LINCOLN

that all men
are created equal.

If I were to read,
much less answer,
all the attacks
made on me,
this shop might
as well be closed
for other business.

A. LINCOLN

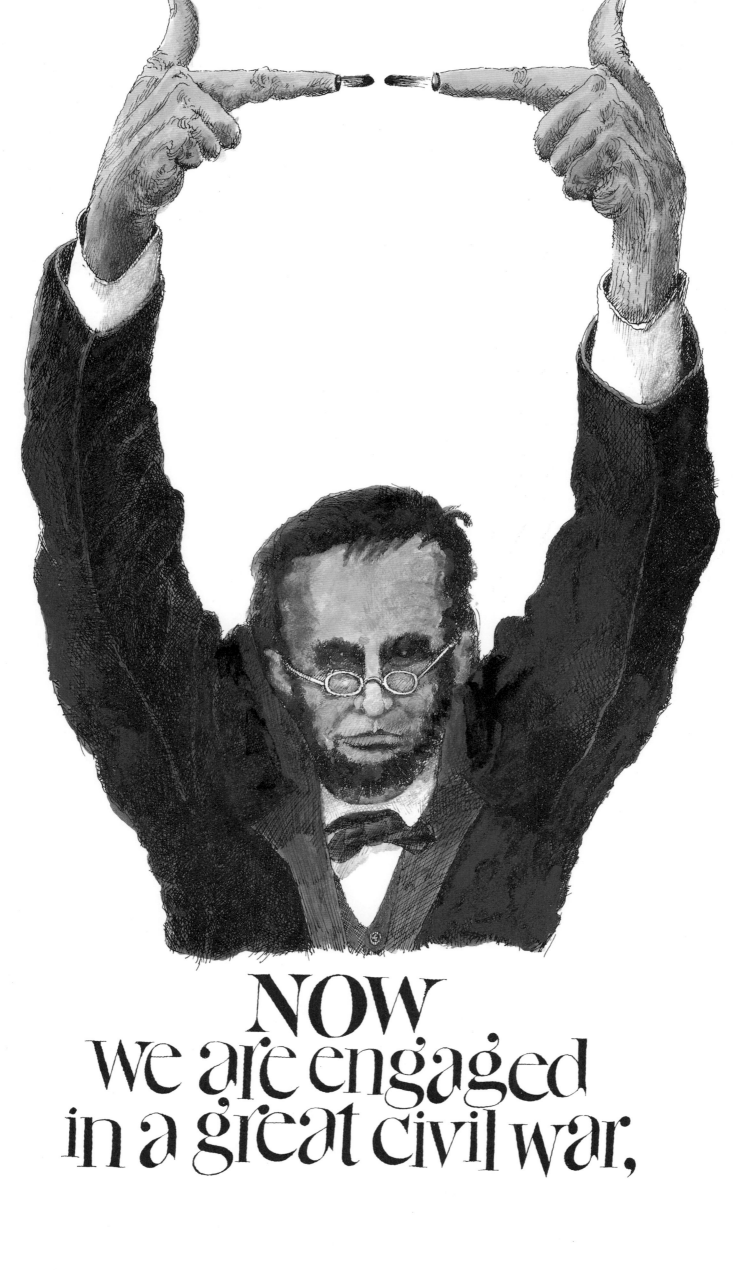

NOW
we are engaged
in a great civil war,

Lincoln had
faith in time,
and time
has justified
his faith.

BENJAMIN HARRISON

testing
whether
that nation,

or any nation,

While the people
retain their virtue
and vigilance,
no administration,
by any extreme
of wickedness
or folly, can very
seriously injure
the government
in the short span
of four years.

A. LINCOLN

So conceived,
and
so dedicated,
can long endure.

He has doctrines,
not hatreds and is
without ambition
except to do good
and serve his country.

ELIHU WASHBURNE

We are met here
on a great battlefield
of that war.

Die when I may,
I want it said of me
to those who know
me best that I have
always plucked
a thistle and planted
a flower where
I thought a flower
would grow.

A. LINCOLN

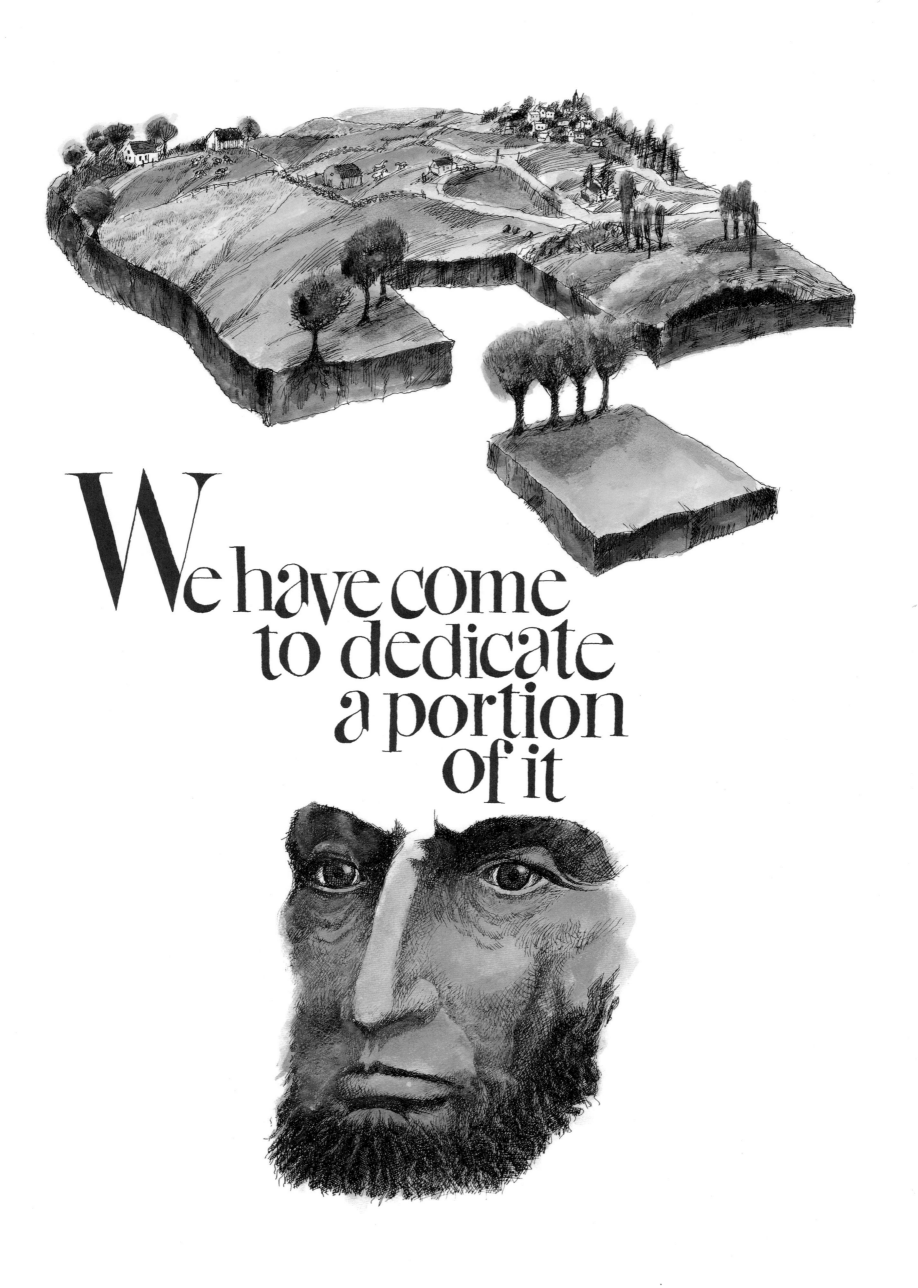

We have come
to dedicate
a portion
of it

Here was a man to hold
against the world,
A man to match
the mountains
and the sea.

EDWIN MARKHAM

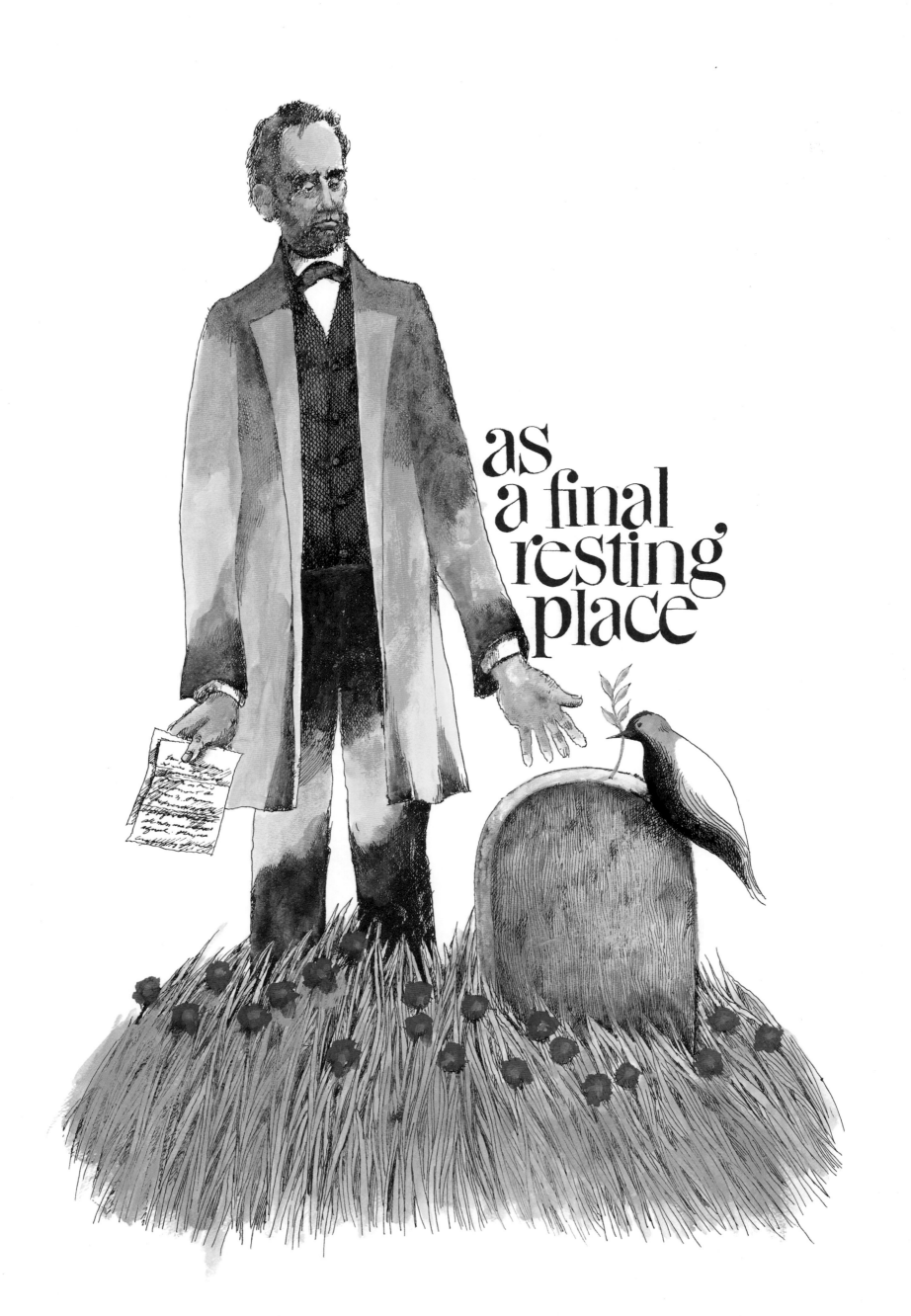

as
a final
resting
place

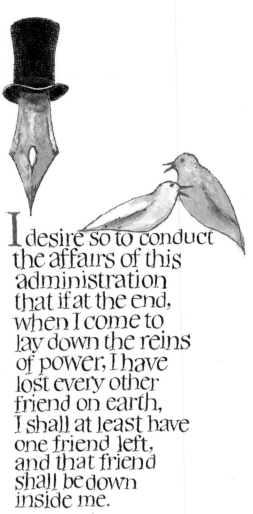

I desire so to conduct
the affairs of this
administration
that if at the end,
when I come to
lay down the reins
of power, I have
lost every other
friend on earth,
I shall at least have
one friend left,
and that friend
shall be down
inside me.

A. LINCOLN

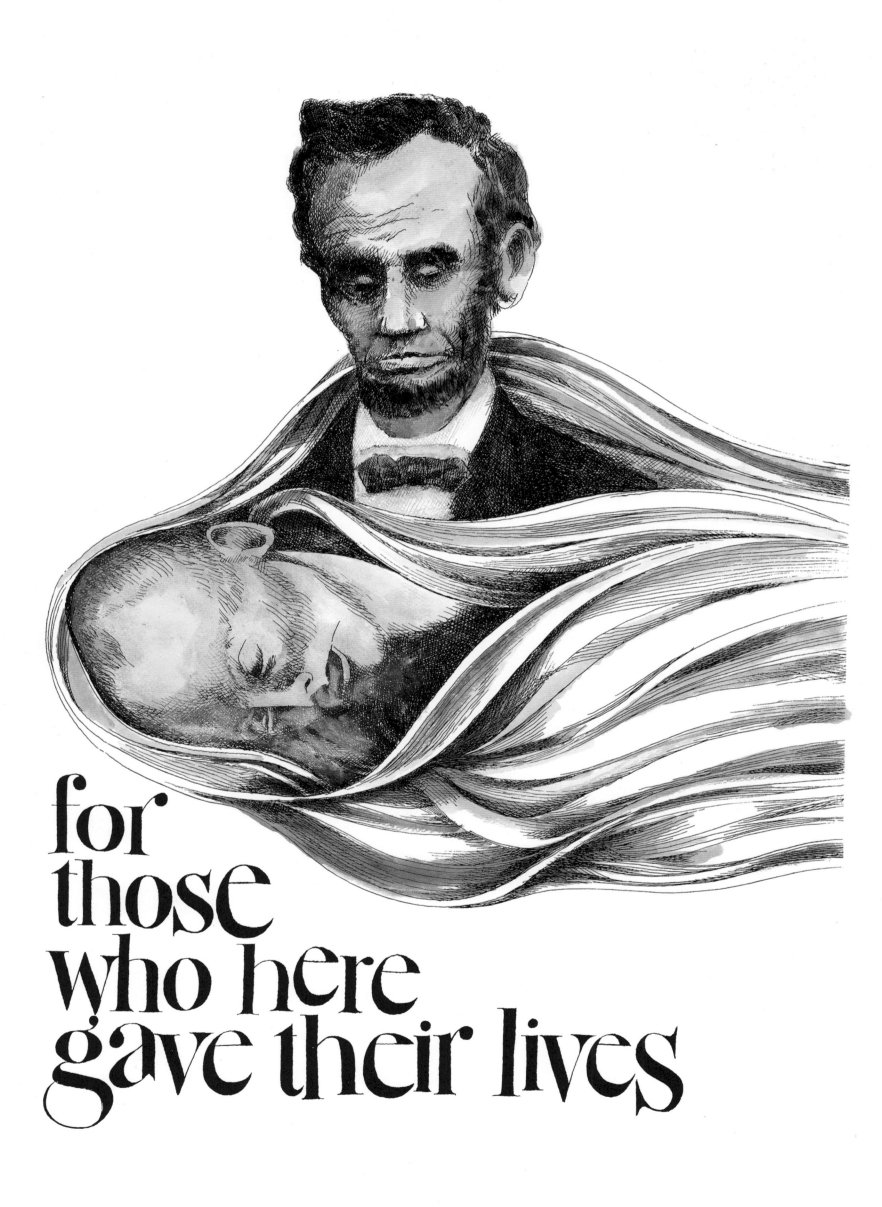

for
those
who here
gave their lives

His heart was as great as the world, but there was no room in it to hold the memory of a wrong.

RALPH WALDO EMERSON

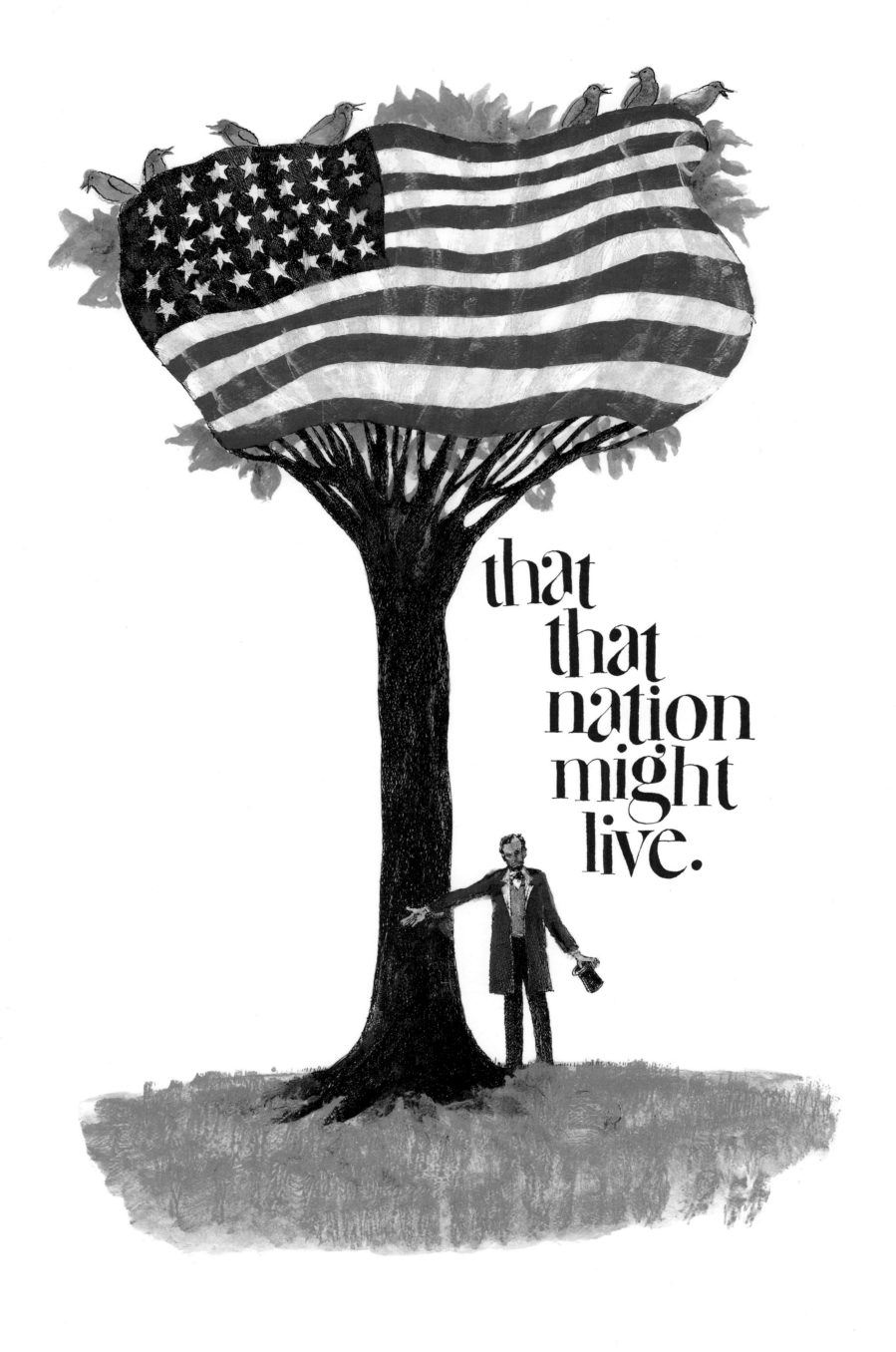

that
that
nation
might
live.

If the good people,
in their wisdom,
shall see fit
to keep me
in the
background,
I have been
too familiar
with
disappointments
to be very much
chagrined.

A. LINCOLN

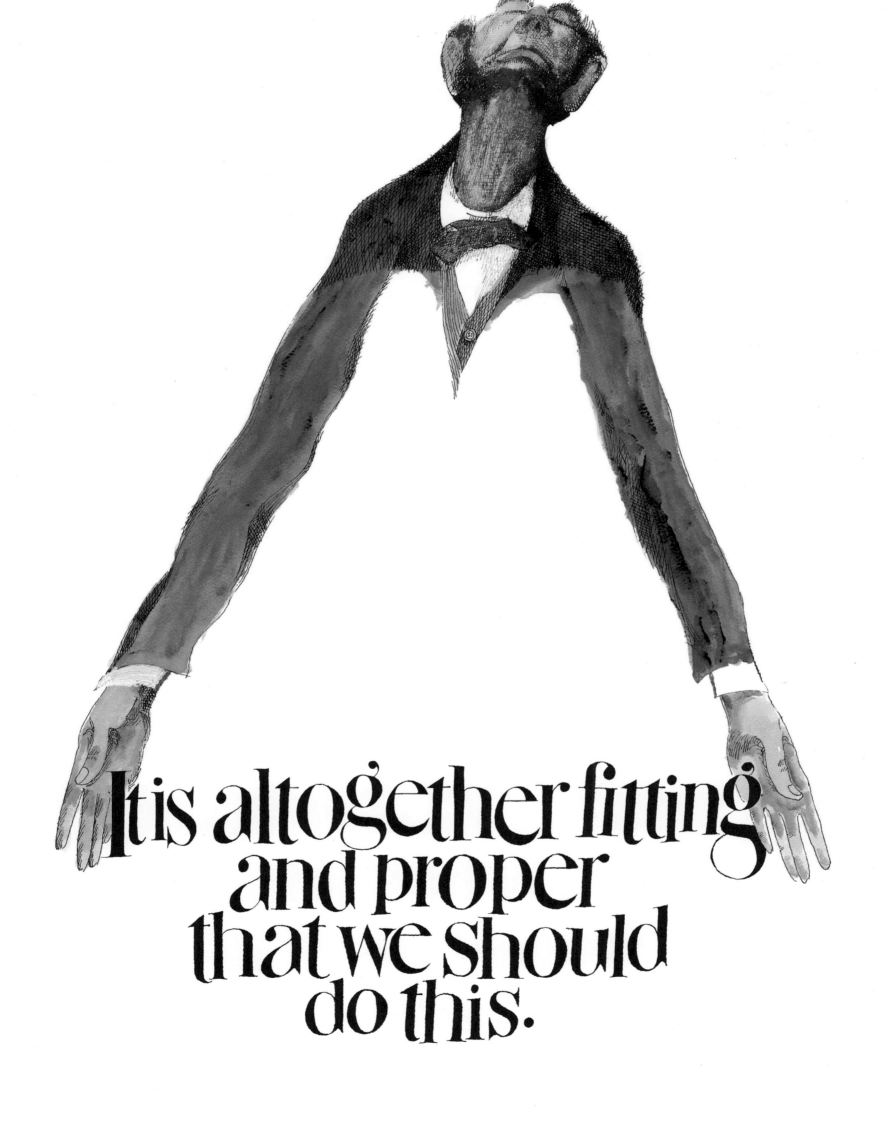

It is altogether fitting and proper that we should do this.

He read diligently,
studied in the daytime,
didn't after night much,
went to bed early,
got up early,
and then read,
eat his breakfast,
got to work in the field
with the men.
Abe read all the books
he could lay his hands on,
and when he came across
a passage that struck him,
he would write it down
on boards if he had
no paper and keep it there
till he did get paper,
then he would rewrite it,
look at it, repeat it.

SARAH BUSH JOHNSTON LINCOLN,
his stepmother

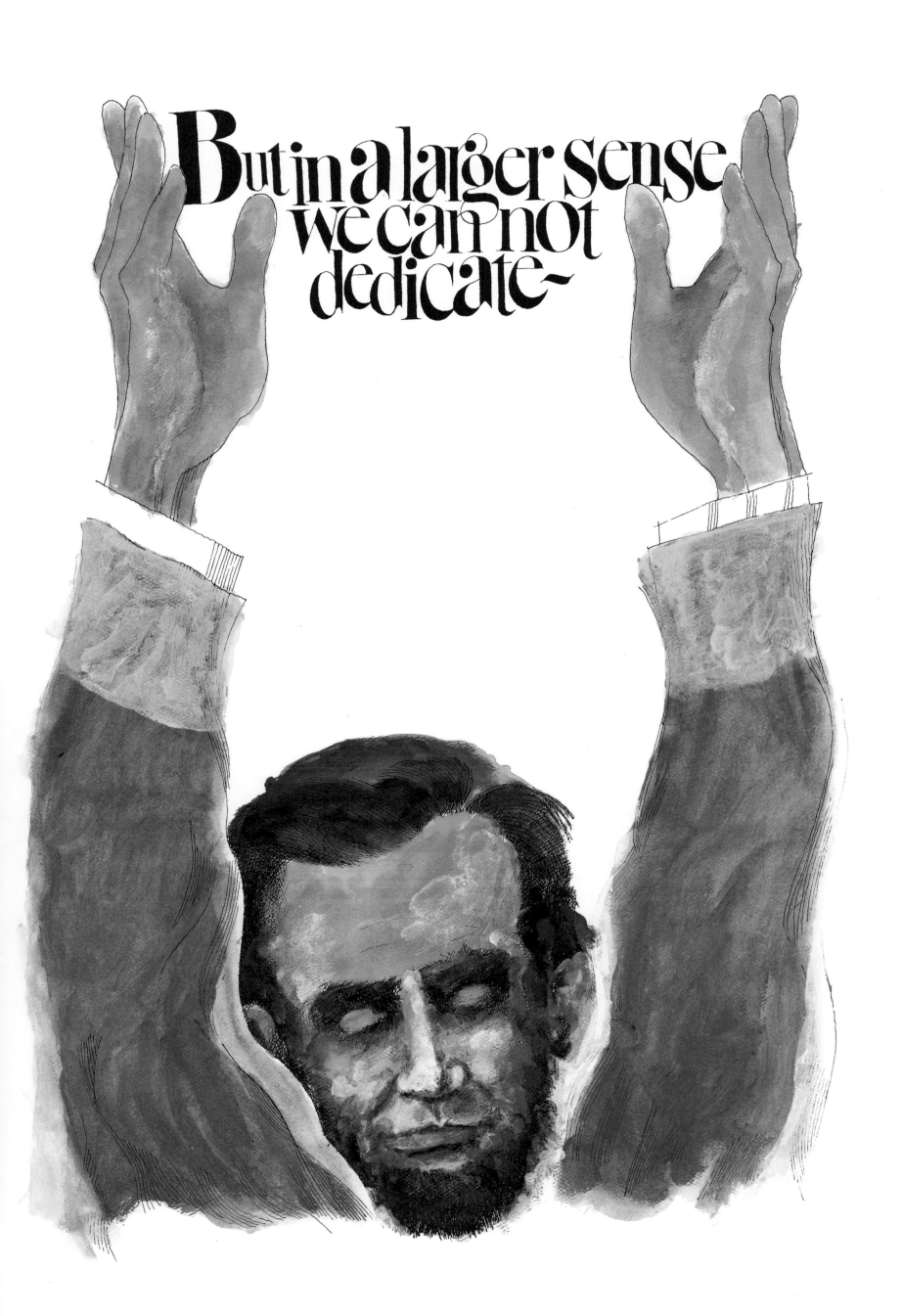

Lincoln was a very
normal man with
very normal gifts,
but all upon a great
scale, all knit together
in loose and natural
form, like the great
frame in which
he moved and dwelt.

WOODROW WILSON

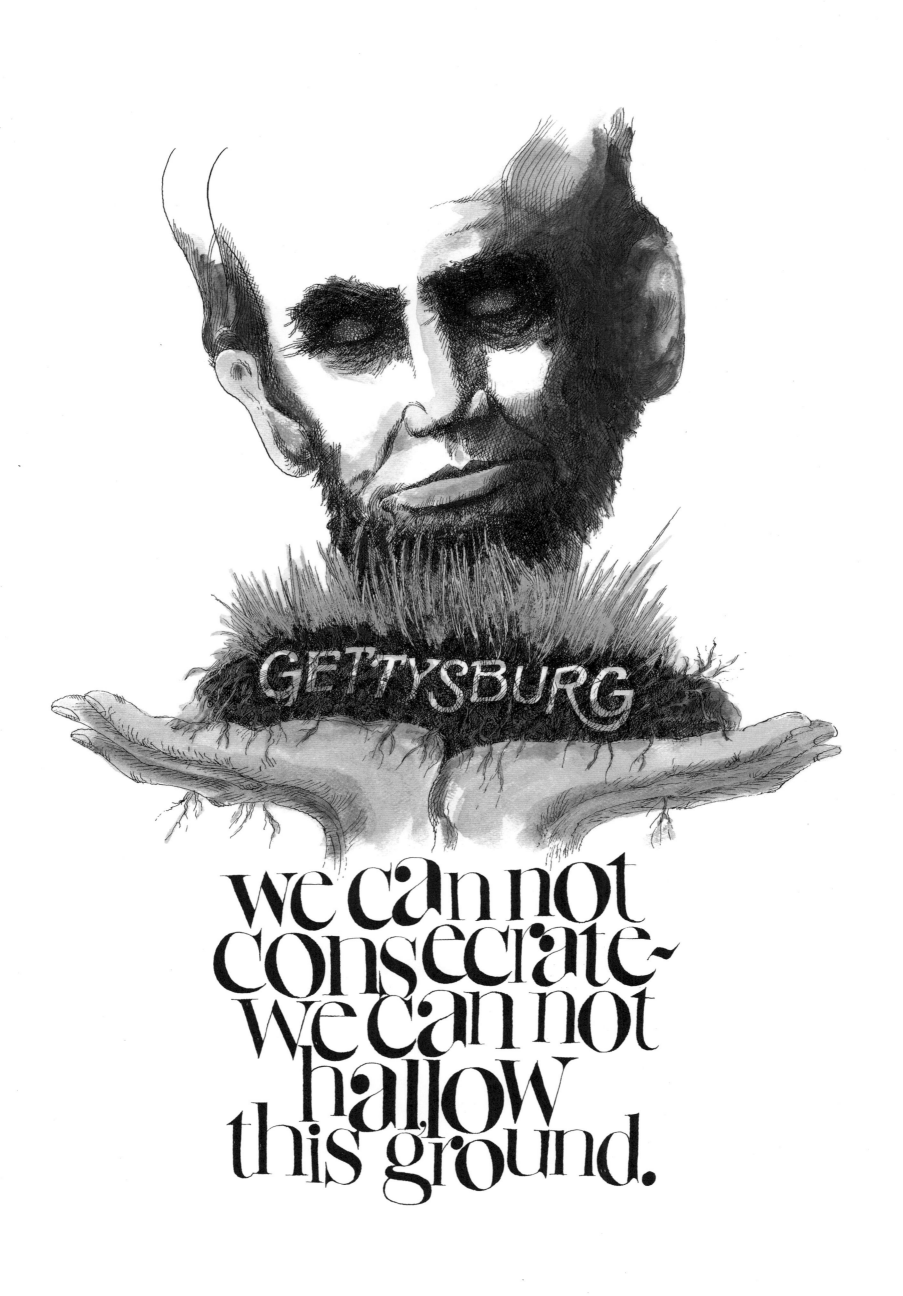

GETTYSBURG

we cannot
consecrate—
we cannot
hallow
this ground.

O Captain! my Captain!
 our fearful trip is done.
The ship has weather'd every rack,
 the prize we sought is won,
The port is near, the bells I hear,
 the people all exulting,
While follow eyes the steady keel,
 the vessel grim and daring;
But O heart! heart! heart!
 O the bleeding drops of red
Where on the deck my Captain lies
 Fallen cold and dead.

WALT WHITMAN

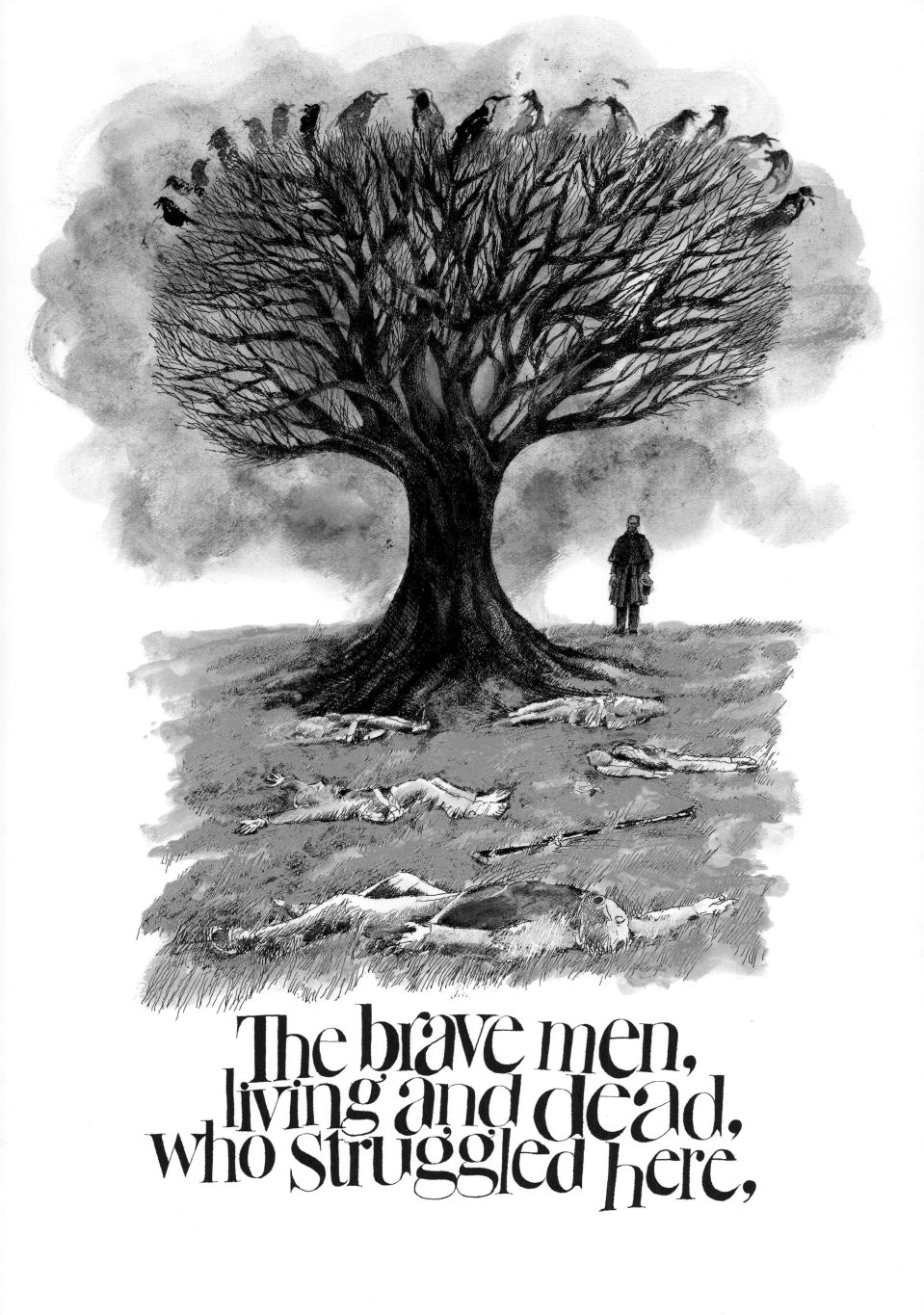

The brave men,
living and dead,
who struggled here,

Some opulent force of genius,
 soul and race,
Some deep life-current
 from far centuries
Flowed in his mind
 and lighted his sad eyes,
And gave his name among
 great names a higher place.

JOEL BROWN

have
consecrated
it
far above
our poor
power
to add
or
detract.

I don't know who
my grandfather was;
I am more concerned
to know what his
grandson will be.

A. LINCOLN

The world
will little note,
nor long remember,
what we say here,

We Americans today
are fortunate that
the statues of Lincoln
we look at have
marble eyes.
Were they human eyes,
I fear we would wilt
before their honest
return gaze.

KARL F. VOLLMER

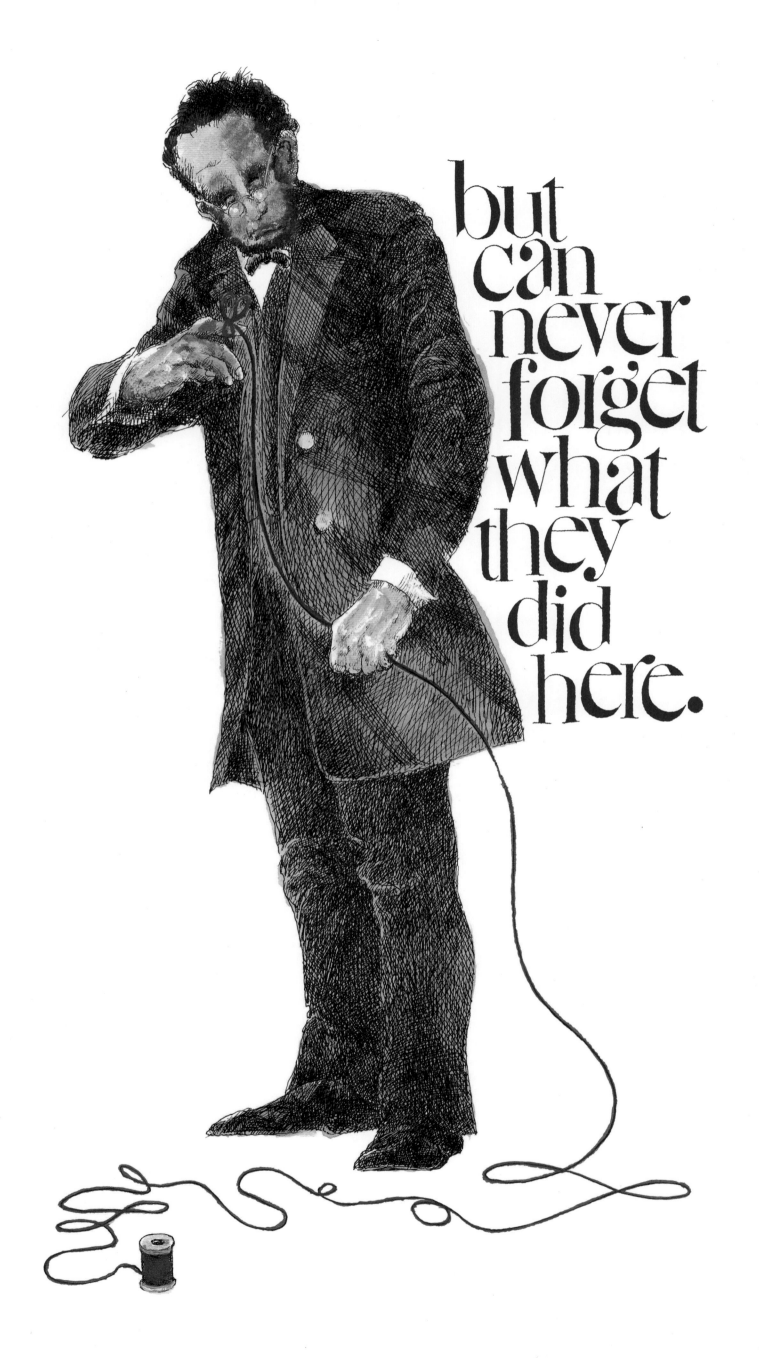

but
can
never
forget
what
they
did
here.

A blend of mirth and sadness,
 smiles and tears;
A Quaint Knight-errant
 of the pioneers;
A homely hero,
 born of sod;
A Peasant Prince;
 a Masterpiece of God.

WALTER MALONE

It is for us, the living, rather
to be dedicated here

If destruction be our lot
we must ourselves
be its author and finisher.
As a nation of freemen
we must live
through all time,
or die by suicide.

A. LINCOLN

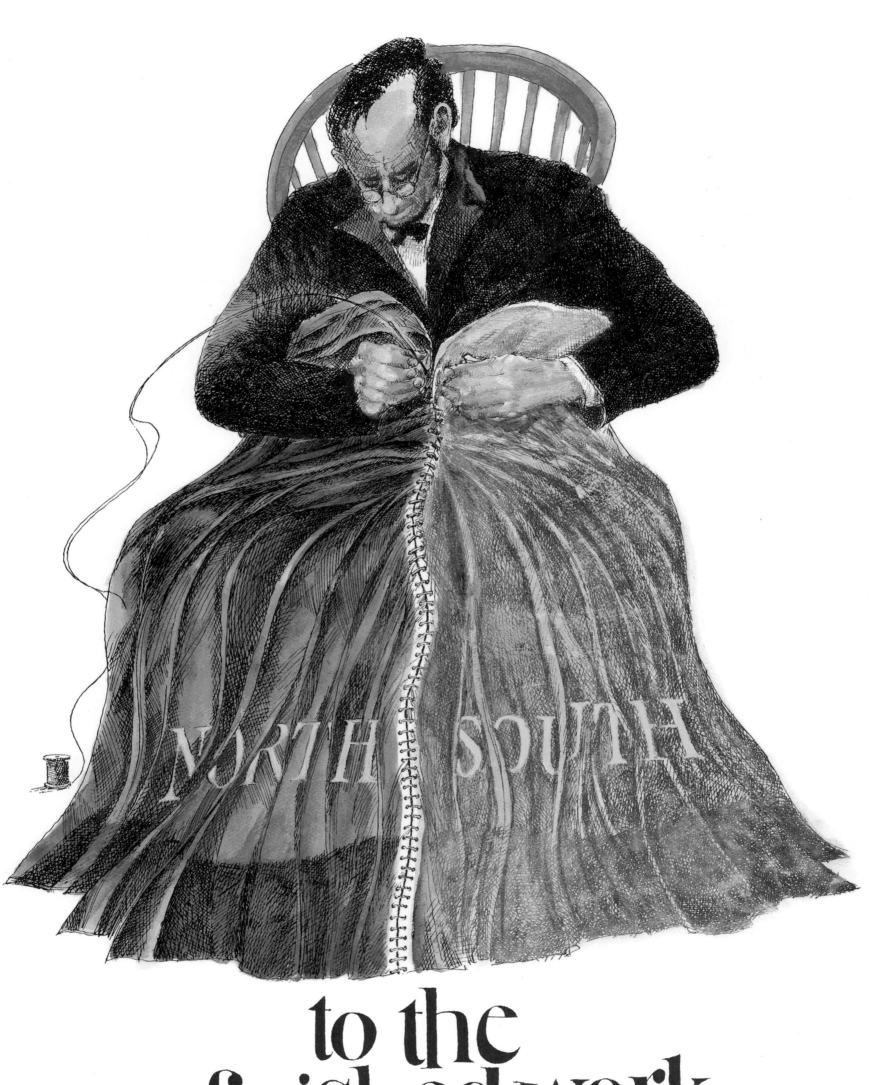

NORTH SOUTH

to the unfinished work

This war
is eating
my life out.

A. LINCOLN

which they
have, thus far,
so nobly carried on.

The stuff of which
he is made
must be as stern
as the aspect
of our days.

H. VILLARD

It is rather for us to be here dedicated

Addressing a Cabinet Meeting.

Gentlemen: I have, as you
are aware, thought a great
deal about the relation
of this war to slavery...
Several weeks ago,
I read an order on this subject...
which on account of objections,
made by some of you,
was not issued.
Ever since then my mind
has been occupied
with this subject...to issue
a Proclamation of Emancipation.
I said nothing to anyone
but I made a promise
to myself, and...to my Maker.
I am going to fulfill that promise.
I have got you together
to hear what I have written down.
I do not wish your advice
about the main matter;
~for that I have
determined for myself.

A. LINCOLN

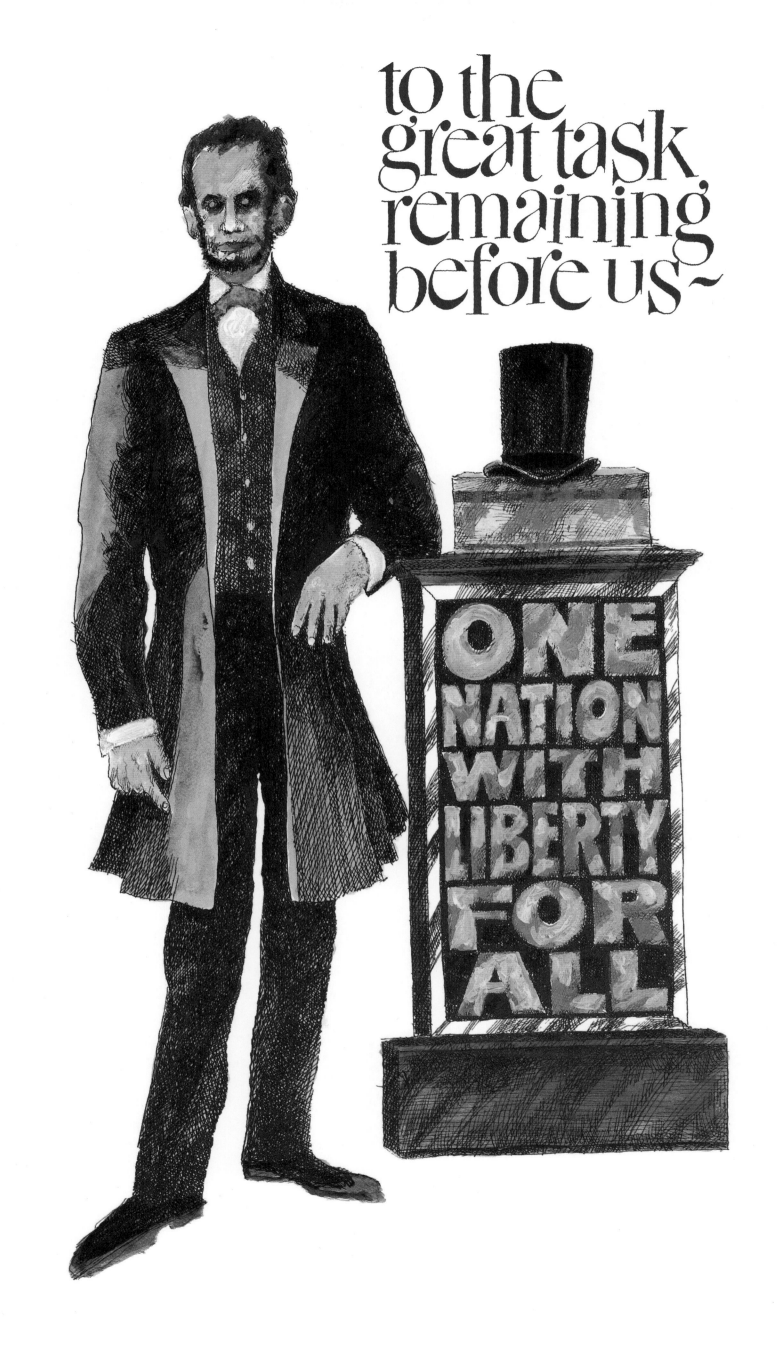

Let us have faith
that right
makes might,
and in that faith,
let us,
to the end,
dare to do
our duty
as we
understand it.

A. LINCOLN

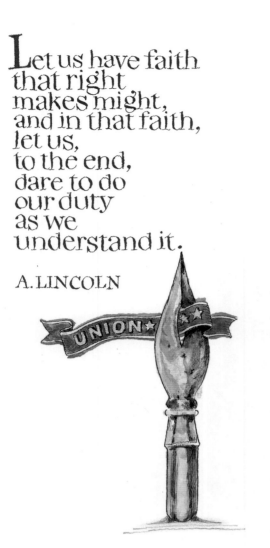

that from
these honored dead
we take
increased devotion

With malice toward none,
with charity for all,
with firmness in
the right as God gives us
to see the right,
let us strive on to finish
the work we are in,
to bind up
the nation's wounds,
to care for him
who shall have
borne the battle
and for his widow
and his orphan,
to do all
which may achieve
and cherish
a just
and lasting peace
among ourselves
and with
all nations.

A. LINCOLN

to that cause
for which they here gave
the last full measure
of devotion~

Abraham wore
a stovepipe hat
That brushed the stars
where he walked.

JOSEPH AUSLANDER

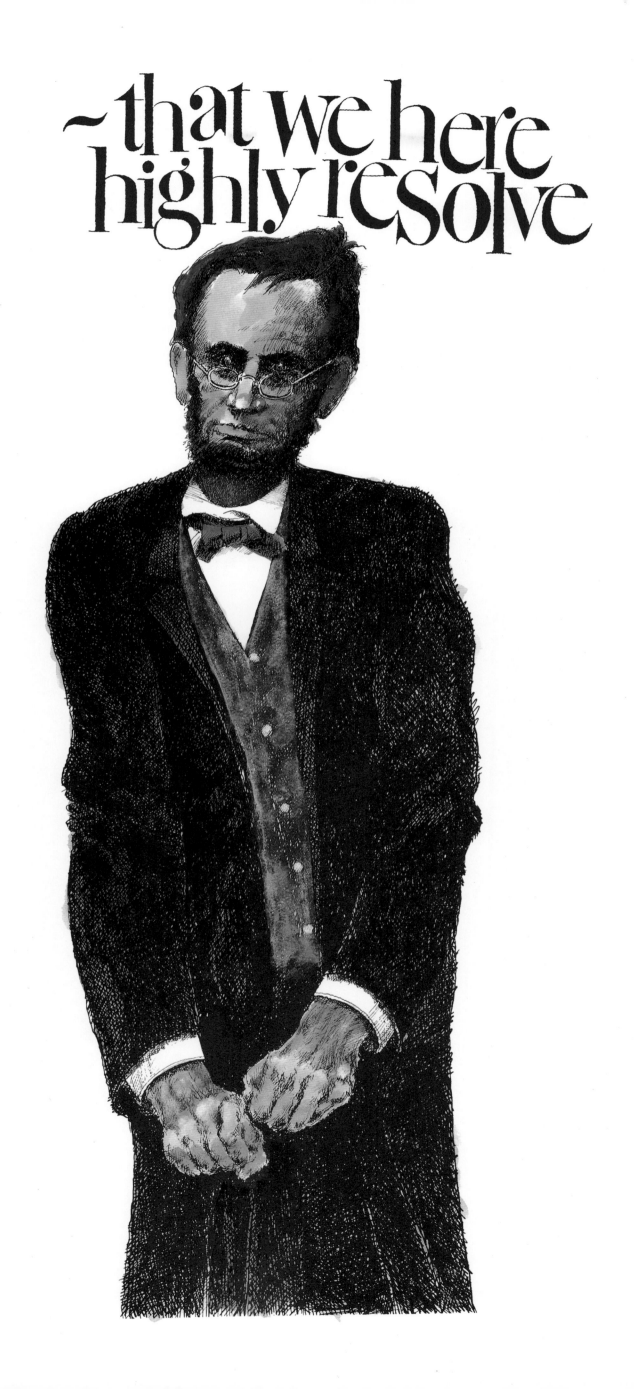

It is said an Eastern
monarch once charged
his wise men to invent
him a sentence, to be
ever in view, and which
should be true and
appropriate in all
times and situations.
They presented him
the words:
"And this, too,
shall pass away."
How much it expresses!
How chastening in
the hour of pride!
How consoling in the
depths of affliction!

A. LINCOLN

that
these dead
shall not
have died
in vain;

Not often in the
story of mankind
does a man arrive
on earth who is
both velvet and steel,
who is
as hard as a rock
and soft as
a drifting fog,
who holds in his
heart and mind
the paradox of
terrible storm
and peace
unspeakable
and perfect.

CARL SANDBURG

that
this
nation
shall have
a new birth
of freedom;

SEEDS
of
FREEDOM

...A kind of passion
with me, and it has
stuck by me;
for I am never
easy now,
when I am handling
a thought
till I have
bounded it north,
and bounded it south,
and bounded it east
and bounded it west...

A. LINCOLN

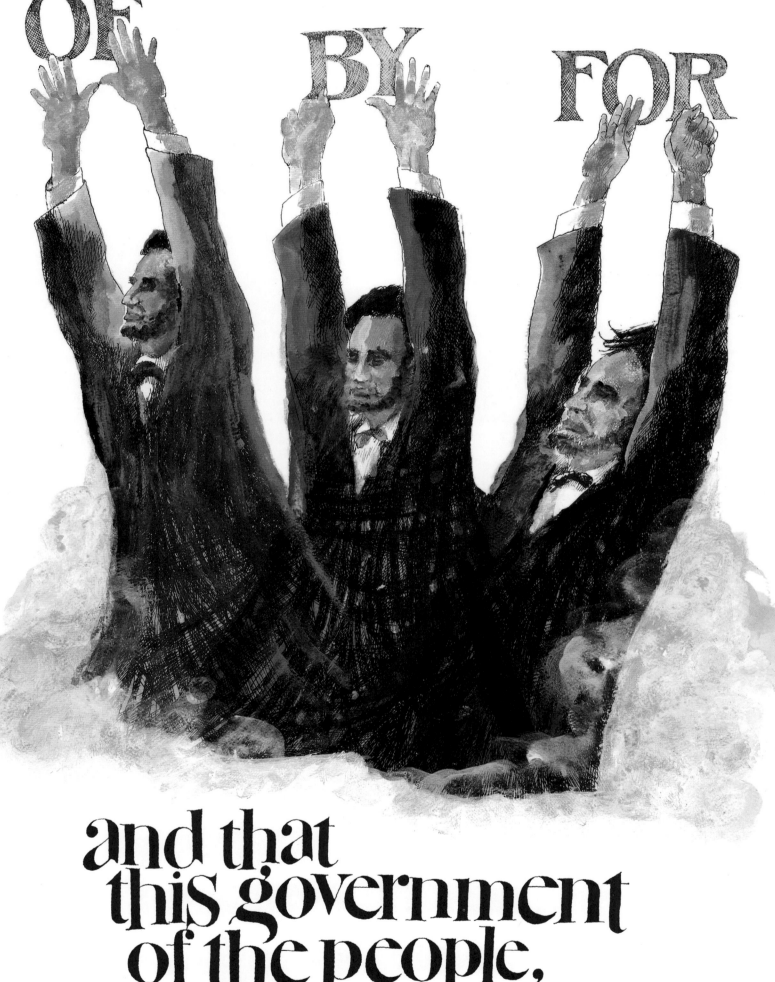

OF BY FOR

and that
this government
of the people,
by the people,
for the people,

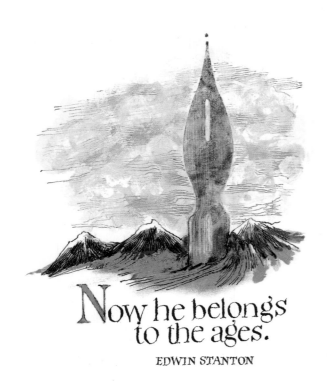

Now he belongs
to the ages.

EDWIN STANTON

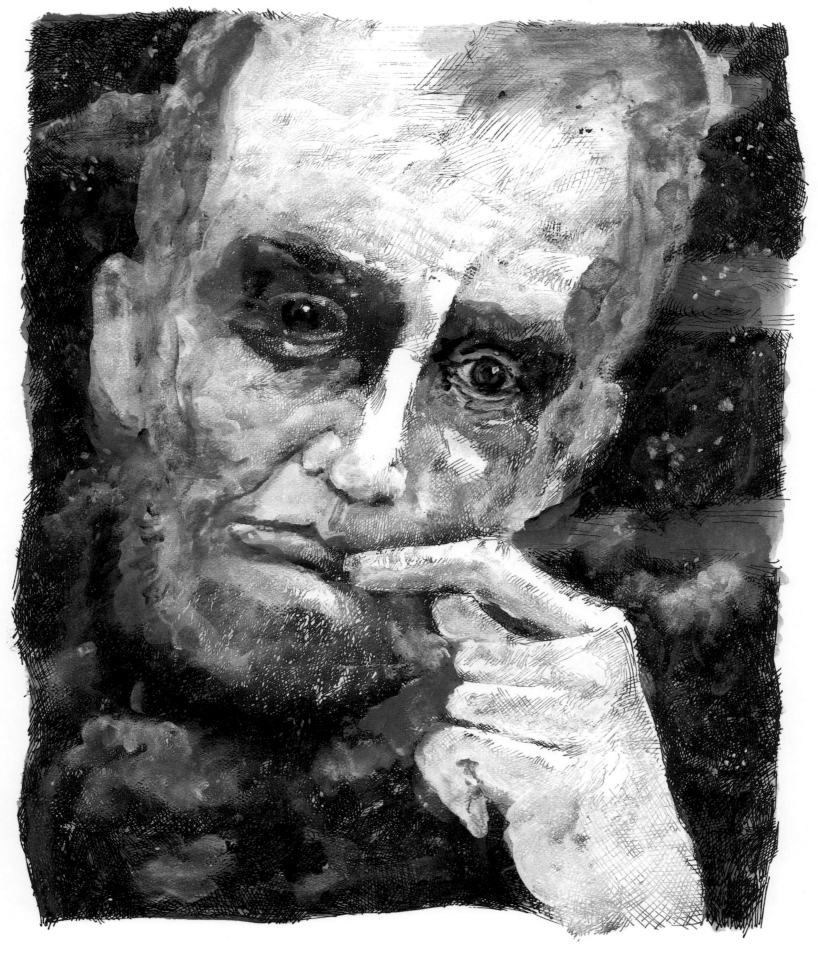

Shall not perish from the earth.

Chronology

December 1774
The Continental Congress bans the importation of slaves.

July 4, 1776
The Declaration of Independence is signed. Under this document, the thirteen colonies build the foundation of a new Union in which all men are created equal.

1780
Pennsylvania becomes the first state to abolish slavery. (Vermont abolished it in 1777 but will not be admitted as a state until 1791.)

1804
New Jersey is the last Northern state to abolish slavery. No Southern state abolishes it.

February 12, 1809
In Kentucky, Abraham Lincoln is born. He and his family live in a one-room log cabin.

1819
The first full-scale debate over slavery in national politics begins. While the territory of Missouri is considered for acceptance as a state, Representative James Tallmadge of New York introduces an amendment to prohibit further induction of slaves in Missouri, as well as a gradual emancipation of the slaves already there. When a vote is held on the amendment, almost every Northern state votes for the amendment and every Southern state votes against it. The issue reaches a stalemate and reveals a new shift in national politics: Voting is now done more along sectional than along party lines.

1820
The Missouri Compromise is passed. As a result, Missouri comes into the Union as a slave state and Maine is admitted as a nonslave state. This preserves the balance between free and slave states. The Missouri Compromise also mandates that the territories north of latitude 36°30' N, gained in the Louisiana Purchase, will prohibit slavery.

August 4, 1834
At the age of twenty-four, Lincoln is elected to the Illinois General Assembly after serving as a postmaster and deputy county surveyor. He will serve two terms in the assembly before being elected to the US House of Representatives.

1854
Having left politics in 1849 to pursue a career in law, Lincoln reenters the political arena. He is inspired to do so by what he sees as troubling new legislation. The Kansas-Nebraska Act proposes to grant the territories "popular sovereignty," allowing the people themselves to decide if slavery should be legal. Lincoln argues fiercely against essentially repealing the Missouri Compromise, saying that without a mandate by the government, humans will sink to slavery again. In his speeches, he comes back to the Declaration of Independence, reminding his audiences of the line "all men are created equal."

1856
With his Whig Party dissolved due to sectional conflict, Lincoln helps form the new Republican Party. The party draws unsatisfied politicians from all parties who unite over the anti-slavery movement.

June 16, 1858
Lincoln begins his bid for the US Senate with an impassioned speech at the Illinois state convention. In this speech, now known as the "House Divided" speech, Lincoln notes that the tensions between free and slave states have risen to a point of no return. He predicts that the country must become one or the other fully in order to function, but does not condone splitting off into two separate entities.

May 18, 1860
Lincoln is nominated as the Republican candidate for president.

November 6, 1860
Lincoln is elected as the first Republican president.

December 20, 1860
Believing that the election results will lead to the abolition of slavery (and an imposition on states' rights), South Carolina secedes from the Union. Within two months, Mississippi, Florida, Alabama, Georgia, Louisiana, and Texas will follow.

February 8, 1861
The Confederate States of America is formed; Jefferson Davis will be elected as its president on February 9 and inaugurated on February 18.

February 11, 1861
Lincoln leaves his home in Illinois to travel to Washington, DC. Rumors of a possible assassination attempt surround him on his trip.

March 4, 1861
Lincoln is sworn in as the sixteenth president of the United States. During his inaugural address, the new president asks his countrymen to act calmly and rationally while stressing the importance of preserving the Union.

April 12, 1861
The Civil War begins at 4:30 AM as Confederates attack Fort Sumter in Charleston, South Carolina. Two days later, a new flag flies over the fort.

April 17, 1861
Virginia secedes from the Union, followed by Arkansas, Tennessee, and North Carolina. The Confederacy now has eleven states.

April 19, 1861
Lincoln issues a blockade of Southern ports. Though it is not initially successful, the blockade will eventually cripple the Confederacy's supply lines.

July 4, 1861
Lincoln declares a state of insurrection, calls for 75,000 volunteer soldiers, and summons Congress into emergency session in an effort to maintain the Union.

July 21, 1861
The Union army makes its first offensive drive at Bull Run (First Manassas).

When Union troops are defeated, the country begins to realize that this will be a long and brutal war.

January 27, 1862
Under General War Order No. 1, all Union forces will begin an advance scheduled to commence on George Washington's birthday.

April 16, 1862
Lincoln signs an act abolishing slavery in the District of Columbia.

September 22, 1862
Lincoln issues a preliminary Emancipation Proclamation.

January 1, 1863
After a series of military defeats, President Lincoln issues a final Emancipation Proclamation. The Union focus now changes from one of preserving unity to one of granting freedom for all.

March 3, 1863
The draft is instituted, calling for the enlistment of all men aged twenty through forty-five. (Men who can afford a three-hundred-dollar fee or provide a substitute are exempted.)

June 3, 1863
Confederate general Robert E. Lee launches his second invasion of the North. Lee, who has been successful thus far in the war, believes the only way to end the conflict is to move out of a defensive mode and go on the attack.

July 1–3, 1863
The Confederates arrive in Gettysburg, Pennsylvania, for what will be the bloodiest battle in the Civil War. After three days and more than forty-six thousand casualties, Union troops defeat the Rebels. Winning this pivotal battle allows the Union army to gain crucial momentum.

July 4, 1863
The South is split in half when Vicksburg, the last Confederate stronghold on the Mississippi River, surrenders to Union general Ulysses S. Grant.

October 3, 1863
The president issues a Proclamation of Thanksgiving, asking the nation's citizens to set aside the last Thursday in November as a day to thank God for their blessings and to heal the wounds caused by the ongoing civil war.

November 19, 1863
To honor the soldiers who died at Gettysburg, a national cemetery is dedicated. The great orator Edward Everett gives a grand two-hour speech. President Lincoln follows with his Gettysburg Address, which lasts only two minutes. However brief, the speech goes on to become a national treasure, calling attention to those who fought to preserve a nation built on equality.

March 9, 1864
Lincoln appoints General Grant commander of the Union army. The president is hopeful that after the long string of unsuccessful Northern generals, Grant will be able to bring the war to the South and end it once and for all.

April 8, 1864
The Thirteenth Amendment, which formally abolishes slavery in the United States, is passed by the Senate. A subsequent vote in the House is defeated.

May 4, 1864
Under the new command of Grant, the Union army begins a sweeping campaign. Grant takes his troops to Virginia while General William T. Sherman drives toward Atlanta.

August 29, 1864
As the war rages on, Democrats nominate George B. McClellan to run against incumbent Lincoln.

September 2, 1864
General Sherman and his army succeed in capturing Atlanta, giving a boost to Lincoln's run for reelection.

November 8, 1864
Lincoln is reelected with 55 percent of the popular vote and 212 of 233 electoral votes.

January 31, 1865
The House, after President Lincoln employs his political skill and influence, finally passes the Thirteenth Amendment. The next day, Lincoln will approve the Joint Resolution of Congress submitting the proposed Thirteenth Amendment to the state legislatures for ratification.

March 4, 1865
Lincoln delivers his second inaugural address, which is now inscribed along with the Gettysburg Address at the Lincoln Memorial in Washington, DC. In this somber speech, he draws attention to the wrongs committed by both sides of the war and asks God for help in finding peace. His speech illustrates his belief that when it is time for Reconstruction, all parties should be pardoned speedily and magnanimously.

April 2, 1865
After a nine-month standoff with Lee's armies, Grant pushes through and raises the Stars and Stripes over the Confederate Capitol in Richmond, Virginia.

April 9, 1865
Lee surrenders his Confederate army to Grant in Appomattox Court House, Virginia.

April 14, 1865
John Wilkes Booth shoots President Lincoln during a play at Ford's Theatre.

April 15, 1865
President Abraham Lincoln dies. His vice president, Andrew Johnson, assumes the presidency.

April 18, 1865
General Joseph Johnston surrenders to Sherman in North Carolina.

May 1865
The last of the Confederate armies surrender as the war ends. More than 620,000 American soldiers have died as a result of the war. The number of civilian casualties is unknown. The nation is, painfully, reunited.

December 6, 1865
The Thirteenth Amendment to the US Constitution is ratified, abolishing slavery.

It is not merely
for today, but for
all time to come
that we should
perpetuate for
our children's children
this great free government
which we have enjoyed
all our lives.

A. LINCOLN

Amendment XIII

Section 1. Neither slavery nor involuntary servitude, except as punishment for crime whereof the party shall have been duly convicted, shall exist within the United States, or any place subject to their jurisdiction.

Section 2. Congress shall have power to enforce this article by appropriate legislation.

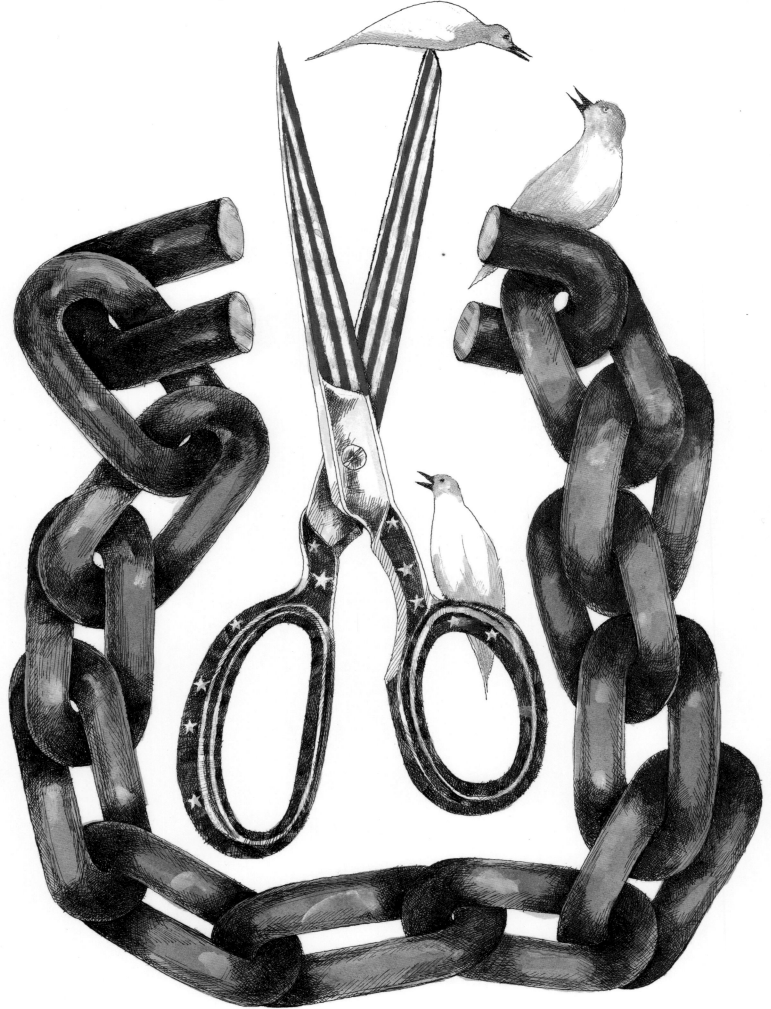